DELACROIX

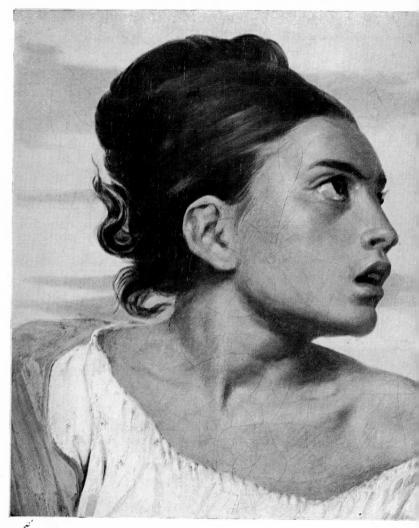

The Orphan in the Cemetery / Paris, Louvre

DELACROIX

BY

JEAN PELLOTIER

TRANSLATED FROM THE FRENCH BY
LUCY NORTON

Published by
THE HYPERION PRESS
Distributed by
THE MACMILLAN COMPANY, NEW YORK

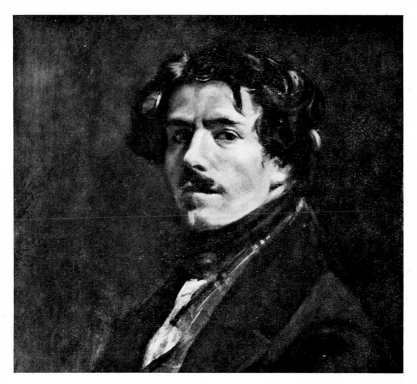

Portrait of Delacroix / detail / Paris, Petit Palais

DELACROIX

L OOKING at the *Self-portrait*, where he has used blacks and olive green
with a liberal hand, we are shocked by the palour of the face. The muscles
are taut and the blood flows slowly through the veins. We see how stiffly
the neck is held, and the lank, clammy hair — signs of a passionate nature.
The face is instinct with life and stubborn rebellion, but a greenish tinge
overshadows the waxen colour of the flesh. These symptoms of spleen and

5

passion became more marked as Delacroix grew older, until, in photographs taken at the end of his life, we notice the network of heavy, dark lines which constant worry has superimposed on the features: "When a man is made wretched by his imagination", he wrote, "to what depths of misery may he not descend! But you know my life, and my life is my nerves, my spleen, my constitution, or rather, the fever that is within me." But the most striking thing about the self-portrait is the effect it gives of a man listening intently to the beating of his own heart, a man confined within a world of intensified emotion.

In *The Entry of the Crusaders into Constantinople*, we see fires quivering in the sunlight, stabs of light re-echoing like sounds to the furthest ends of the town.

In *Hamlet and the Gravediggers*, the gestures and voice of the gravedigger reverberate in a great emptiness, a sombre dialogue beneath the vault of the sky. Such canvases as these were Delacroix's vindication and his deliverance. In them he relaxed his mental tension and fell back on his instinct and imagination, admitting the truth that a painter cannot pull his work together by force of will, nor make a satisfactory picture by obeying rules of colour, but only by his personal feeling. In the highly imaginative world of his creation Delacroix could allow himself no relief, however much he may have desired it. He fully realised, as his studious life proves, that had it only been possible for him to live entirely in his painting there would have been an end to all his troubles: "If I could but live by the spirit alone!"

That is why it is so disturbing to think of paintings by Goya and Rubens, and then of works by Delacroix. The two first-named artists unified their compositions through the inner life of the picture itself. In the *Crucifixion*, at Antwerp, for example, we see tortured flesh and tortured draperies; in Helena Fourment, rich blood flowing beneath the skin; in Goya's portraits, brilliant eyes and a host of white specks pulsating on an inky-black background — a chord of passion. In Delacroix, on the other hand, the unity of the picture is reached by means of colour.

Except in his youth and old age, when he was saved by the stimulus of Baroque invention, he suffered from the typical French love of logic and demonstration, a weakness which also affected some of Cézanne's paintings.

A still more striking comparison, however, is that of the treatment of the eyes in paintings by Goya and Manet, and by Delacroix. With Goya and Manet, eyes are represented as colour, a dark patch being all that one can see in the face. With Delacroix, there are simply gradations of tones placed side by side.

His way of life certainly allowed Delacroix no rest, or rather, his unhappy temperament prevented him from finding the security and peace of mind

6

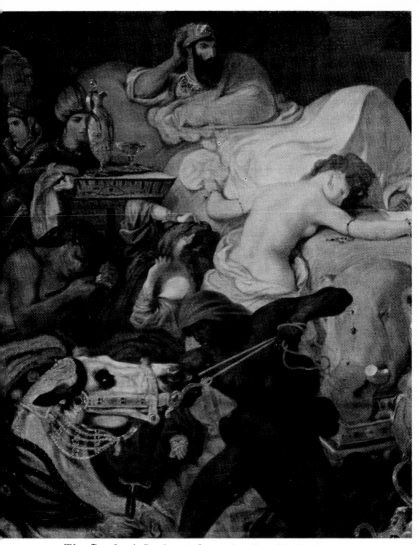

The Death of Sardanapalus | detail | Paris, Louvre

which he never ceased to demand from his work: "To feel satisfied with oneself is worth everything." Intense boredom, which has caused the greatest minds to lust for power and to dream of wars and destruction, led him into dangerous thoughts; his friendships and love affairs were violent and uneasy: he knew the heights and depths of a neurotic nature. It kept him in that state of over-excitement when an artist is liable to create strong effects by violent contrasts, or strange associations by abrupt descents from one world to another, in a restless striving to break the monotony of prolonged meditation. His temperament made him the romantic, the inevitable painter, whom Baudelaire saluted in 1848: "Perfect though Raphael is, he is but a mind endlessly searching after solidity, but that rascal Rembrandt is a mighty idealist, who makes us dream and guess at things that lie beyond, yet Rembrandt is a harmonist and not a pure colourist. How novel the effect will be, how delightful romantic art, if a powerful colourist can realise our emotions and our most precious dreams in colour appropriate to the subject."

In his smallest pictures the restricted space is full of symbols: "Delacroix was madly in love with passion and coldly determined to find some means of expressing it in the clearest possible way." In *The Battle of Poitiers* (1830), for example, the black and red streaks on the purplish-blue of the background are symbolic; although the forms are thin and pointed they give a feeling of suffocation. There are symbolic contrasts in *The Battle of Nancy* (1831), symbols in the scarf fluttering wildly against the dark wave in *Christ on the Lake of Genesareth*, in the ominous turning motion of the boat in *The Bark of Don Juan* ("A terrifying murmur arose like the dreadful voice of despair; each man could read his thoughts in the faces of his companions") a symbol in the cloak of the shipwrecked man, flapping between sky and waters. Such symbols become increasingly eloquent and real.

In his very first important picture, *Dante and Virgil*, Delacroix was able to express himself forcefully. It was a foretaste of his genius. He already knew how to create gestures full of meaning, and an ominous sense of depth, by his admirable arrangement of details: the white body, for instance, pushed head over heels by the boat in its passage, the man standing in the boat with knees apart, bracing himself against the force of the storm, and in the centre, the horrified expression of the head on the farther side. These are plainly symbols beneath the dark and stormy sky. Admittedly, this painting had not yet the brilliant colour-scheme of *The Entry of the Crusaders*. What made Delacroix the great genius of the Romantic Movement was the art of harmonizing dramatic gestures, and his ever increasing command of space composition.

8

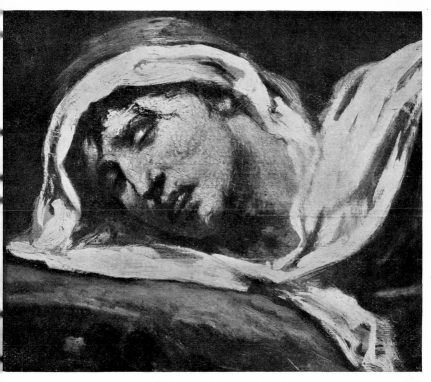

The Cadaver / Private Collection

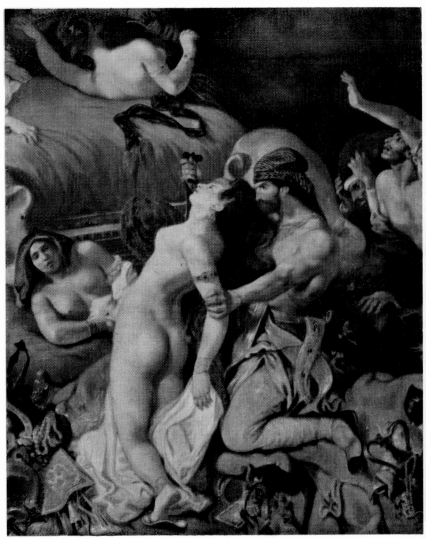

The Death of Sardanapalus / detail / Paris, Louvre

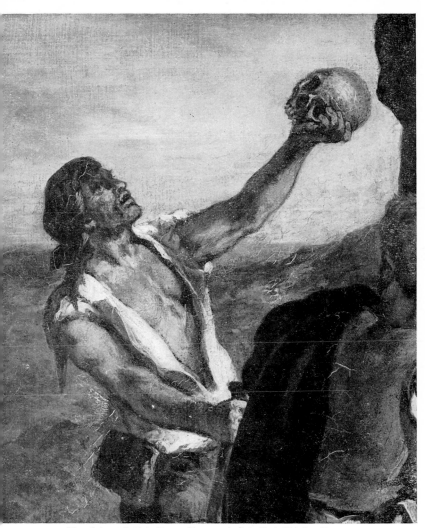

Hamlet and the Gravediggers / detail / Paris, Louvre

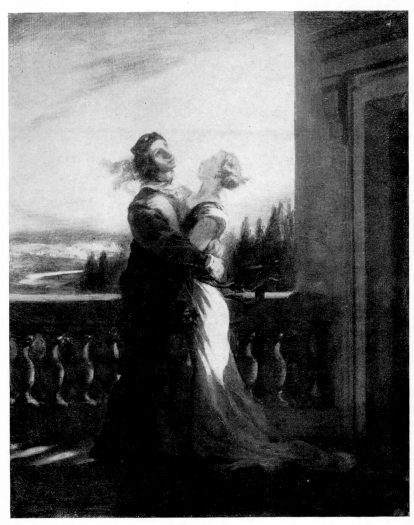

Romeo and Juliet / Paris, Louvre

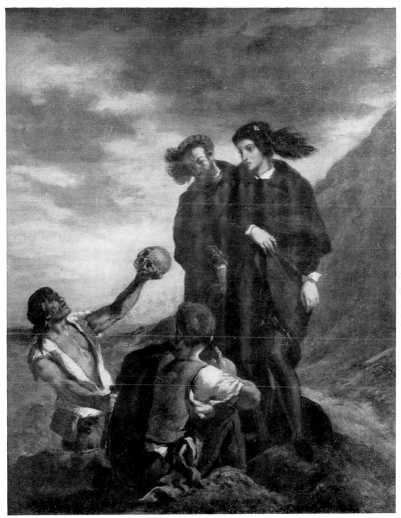

Hamlet and the Gravediggers / Paris, Louvre

Even standing at a great distance from this picture (*The Entry of the Crusaders*), when he is still too far away to distinguish the subject, the beholder has a presentiment of the effects that will move him deeply: the storm rolling round the sky, echoing the anxious dialogue of the two leaders, the lazily flapping standards, casting patterns of light and shadow upon the breasts of the horsemen, the dark, hairy soldier coming down on the left, the gesture of the old man, the scream of the man with his throat cut. These are examples of Delacroix's genius for symbolism, but he also gave them room to move and breathe and, above all, he had the power to exalt the whole subject by merging together heaven and earth, and to bring relief to each separate part by letting in light and air.

At this period Delacroix's handling was like that of Titian at his most dramatic (*The Entombment*, at Milan). He used swift, slanting strokes which managed to convey the form at the same time: "I discovered painting when I had no longer teeth nor breath."

Here Delacroix approaches the sublime which, properly speaking, implies sympathy with a power that we feel to be terrible. It means that he accepted his own destiny and adapted his character to the inevitable. He was thus able to paint horrible crimes and mental tortures in delightful colours - witness the pile of murdered women in *Sardanapalus*.

"When something frightens me I make a picture of it." (Goethe). At such times Delacroix was able to be at peace with himself. He suffered for it, and his suffering justified his simplicity. In other words, in striving to come to terms with the irreconcilable his suffering put him into such a state of mental agitation that he finally broke free and was able to express himself fluently. That explains how we can speak of simplicity as though it were a part of the painter's system. Delacroix knew that it could not be attained to by will power, but only by suffering and acceptance. All of which raises the question of the place of ethics in the life of an artist. Yet Delacroix was never extravagant, as were so many of his deplorable contemporaries. Take, for example, the picture in the Louvre by Gros, *Napoleon visits the Battlefield of Eylau*: the violent exaggeration of the scene in the foreground on the lower right hand side, the swollen eye of the frightened German soldier, and the deliberate distortion of the man falling over backwards. With Michelangelo, inspiration removed the need for devices like these and gave the work unity.

Delacroix, with his sensitive nature, would never have been satisfied with such vulgarity. His mind was preoccupied with colour and he therefore kept the forms in his pictures simple and austere. He had a genius for lucidity. This artist who criticised Rembrandt for drowning his paintings in shadow, and admired Veronese for being the "nec plus ultra

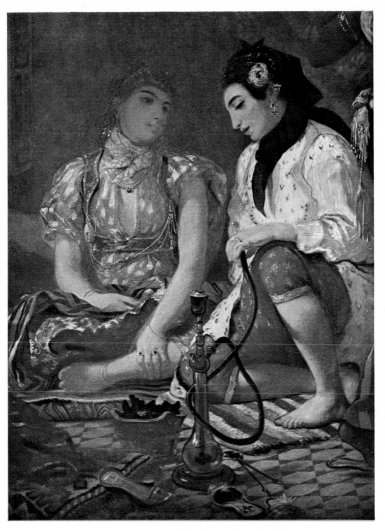

The Women of Algiers / *Paris, Louvre*

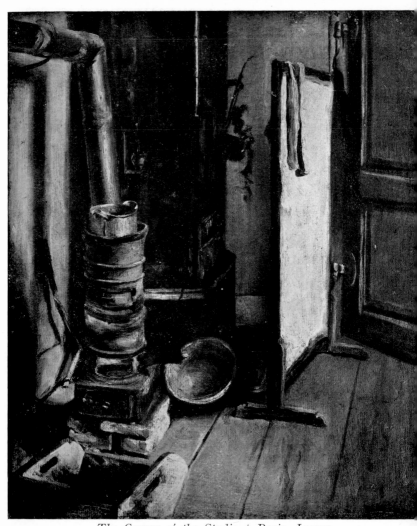

The Corner of the Studio / Paris, Louvre

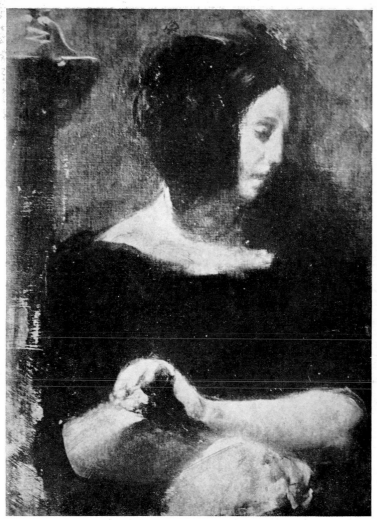

Portrait of George Sand / Copenhagen, formerly Hanson Collection

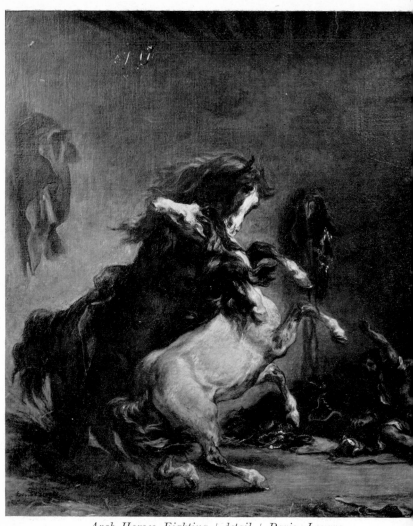

Arab Horses Fighting / detail / Paris, Louvre

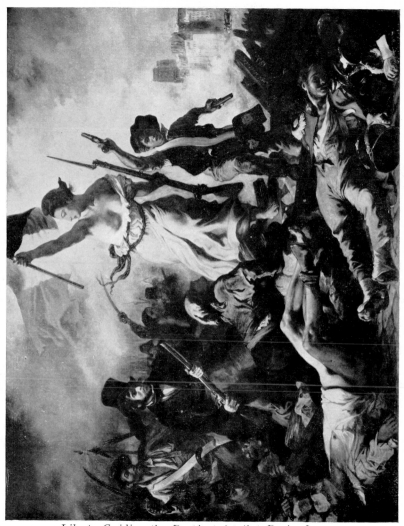

Liberty Guiding the People / *detail* / *Paris, Louvre*

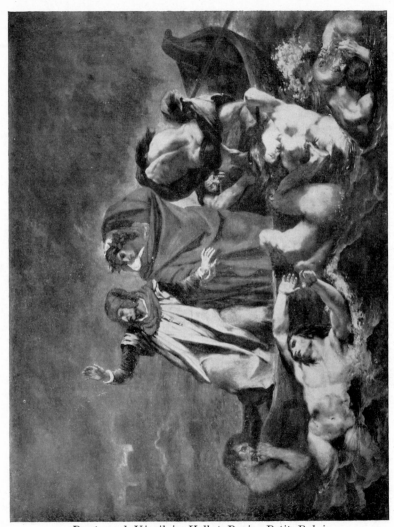

Dante and Virgil in Hell | Paris, Petit Palais

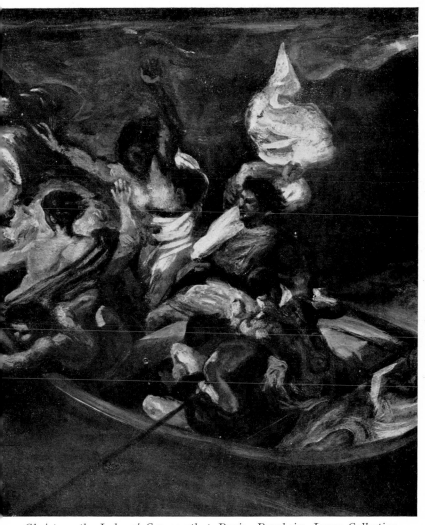

Christ on the Lake of Genesareth / Paris, Bernheim Jeune Collection

of finish in every part of the picture", put his whole soul into colour.

What is more, for men who, like Delacroix, dread boredom, the actual principle of life itself, the scarlet thread, is more important than individuals or objects, which are apt to be ephemeral. This is where he differs from Michelangelo and Goya, who gave expression to the sublime solely by enlarging upon the theme of flesh in light and shadow. For the two latter artists, light and the human body were closely allied, and that was enough. For Delacroix, on the other hand, the chief inspiration was life itself, which he felt a longing to render by means of colour. He may be said to have paved the way for the Impressionists through his love of colour.

His boldest painting is *The Death of Sardanapalus*, in which the colour-scheme is brilliantly arranged. The base of the picture is orange-red contrasting with silvery-green, on which stands the elongated shape of the bed and the blue-white patch made by the reclining figure of Sardanapalus, which gradually fades into the blue-brown of the background. In this picture Delacroix comes near to Rubens, and the effect is a delightful one because the fleshtones are life-like and the paint is spread in broad sweeps and fuller curves.

The Women of Algiers brings some relief to the emotional strain. It represents a scene from a remote world which the beholder may enjoy at his leisure.

At the same period he painted other and less important pictures which, nevertheless, anticipate the future. *Liberty leading the People on the Barricades* is his most modern work. It is painted in bold, flat areas of colour, the pigment thickly laid on in the light passages — an obvious foreshadowing of Manet.

At times Delacroix could be as profound as Rembrandt, witness *St. Sebastian succoured by the Holy Women*, and *The Reclining Odalisk*.

By his insistence on taking colour for his starting-point, and by refusing to be satisfied with himself, Delacroix succeeded in saying the final word on French Classical Painting with his compositions, *Jacob wrestling with the Angel*, and *Heliodorus driven from the Temple*. In these paintings, even the great imaginative force has become objective. Delacroix is no longer straining to create life itself, its only function now is to give movement to the figures and to the painting as a whole; it has become a purely secondary aim. Life appears only in the slight but very powerful torsion of the muscles; but how magnificently he has bound up this tangle of whirling limbs with the general composition. The angel, for example, sweeping down upon Heliodorus to whip him, notice how he is connected with the solid mass of the corner of the Temple; also the crushed arm of Heliodorus, which seems to be fastened down to the step from the muscle upwards.

Before this period Delacroix must have passed through a stage when

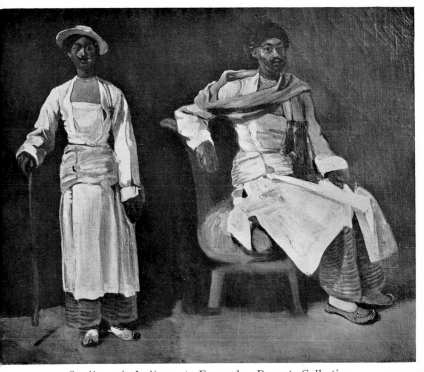

Studies of Indians | Formerly Rouart Collection

his freedom of expression took a different form. At such times his unfortunate tendency to obey conventional form was very noticeable, yet he was exasperated by a longing to express movement.

The Hunts and *Abductions*, and some of *The Horsemen Fighting* are less imaginative. The subject matter is too complicated to be effective, and to compensate for not having thought out the composition clearly he used his skill in a frantic effort to create movement. It was a logical result of his genius. Delacroix was a great colourist, but when his inspiration was not sustained, or his picture insufficiently imagined, he could only succeed in reproducing a conventional world through the intermediary of colour. This is always a danger in taking too positive a line.

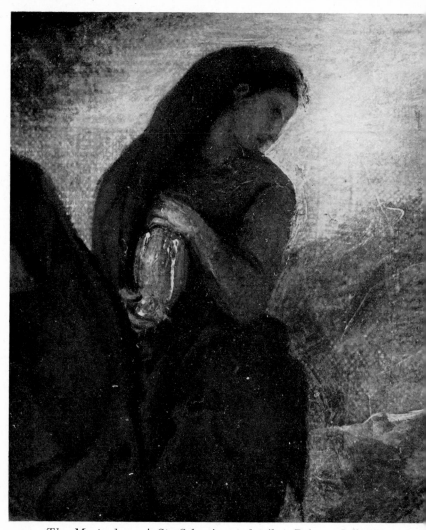

The Martyrdom of St. Sebastian / detail / Private Collection

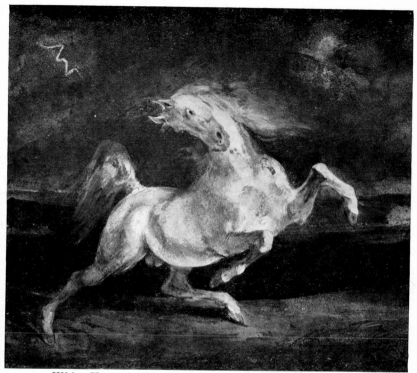

White Horse frightened by a Storm / *Private Collection*

During such periods of strain, however, Delacroix had some splendid days when he was able to relax and enjoy himself at Dieppe; in 1855, for instance, when he painted landscapes with a modern feeling easily and unselfconsciously: "I made a sketch from memory of this sea: fishing boats waiting for the tide to come into harbour."

Out of such moments of relaxation were born the great baroque compositions of his final period, *The Shipwreck on the Coast*, 1862, and *St. George and the Dragon*. By the infinite care which he gave to the details, these paintings seem to partake of cosmic life; his newly acquired power of dynamic draughtsmanship cut through planes and became an actual part of the

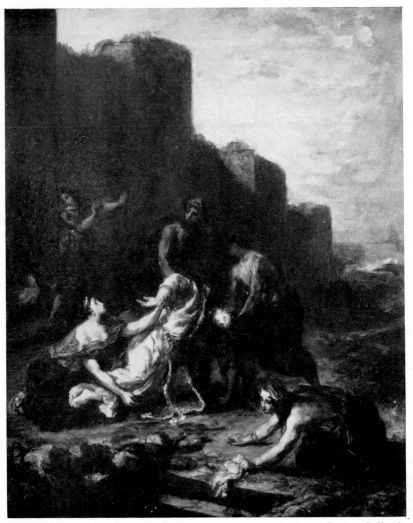

St. Sebastian succoured by the Holy Women / Bernheim Jeune Collection
26

raging of the sea and wind. Yet his feeling for unity was so great that even here the forms are perfectly balanced, and he ended by hollowing out the rocks so that he need paint nothing but the deep troughs and domes of the sea.

In 1848, and after much meditation, he began the sketch for the ceiling of the Galerie d'Apollon. The luminous stream of the river at the bottom of the picture is continued to meet a stormy sky, against which we see the huge coils of a dying serpent; above the clouds the chariot of Apollo is silhouetted against the light. To increase the recession, groups of figures on either side of the picture rise in a column from the earth to the sky. The work has a fine monumental framework inspired by the background to the Sistine Chapel. The forms are simplified by the dazzling light and have sharp contrasts, because they are represented at different angles to the sun in the centre.

This composition has none of the stiffness of the battle pictures; every part is alive with movement in keeping with the grand design, a receding spiral based on masses of light and shadow.

Van Gogh, who came to painting late, suffered as much in his search for a way of life and his inability to express himself, as Delacroix suffered by listlessness and mental agitation. He, too, found release in the colour of the Impressionists. The discovery was perhaps no greater than Delacroix's discovery of the English colourists, but the delay confirmed Van Gogh's romantic temperament and he used colour to serve a different purpose from that of the Impressionists: "I find that everything I learned in Paris is disappearing it will not surprise me much if the Impressionists soon find fault with my painting, which is inspired more by Delacroix than by them."

Both Delacroix and Van Gogh used the same unexaggerated proportions. Both artists preferred to distort the human body (large hands and thin wrists) rather than to magnify its size, but Van Gogh was less sophisticated and as solid as lead. Both men had the same kind of genius; the difference was one of time. Delacroix was the freer, he could escape into books and the society of other men of genius; Van Gogh, the modern, was solitary and impoverished; he remained alone, sitting before a chair or a simple landscape.

The relationship of Cézanne with Delacroix is even more striking, because it seems bound up with comparative failure. I mean his longing to attain to the Absolute through the intermediary of colour — a quest which always eluded Cézanne because this longing, if it is ever to be satisfied, must never be self-conscious. Cézanne came nearest to complete success when he painted those early, unselfconscious still-lives, the *Still-life with the Black Clock*, for instance, which is rich in colour and tactile values and approaches the realistic Delacroix of *The Corner of the Studio*, and *The Portrait of George Sand*.

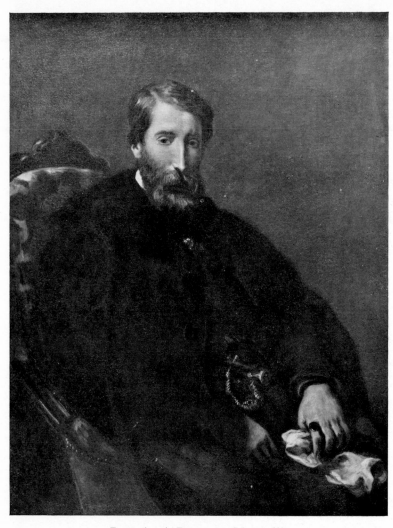

Portrait of Bruyas / Montpellier

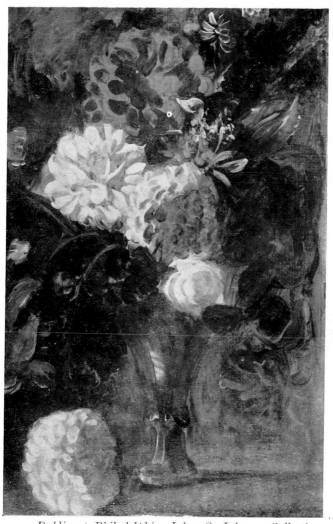

Dahlias / Philadelphia, John. S. Johnson Collection

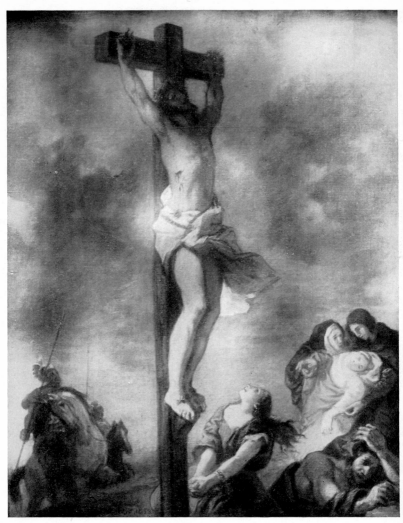

Christ on the Cross / Paris, Bernheim Jeune Collection

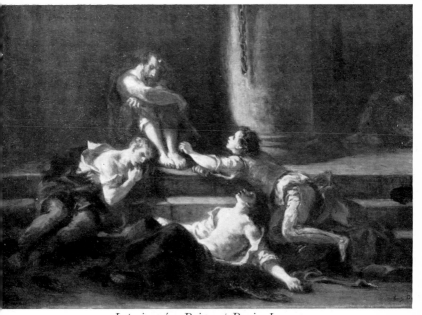

Interior of a Prison / Paris, Louvre

It is difficult to exaggerate the importance of Delacroix. He was the great genius of Romantic Art and set the seal upon French Classical Painting, even more so than Poussin, who was not sufficiently a colourist. He revealed a new approach to painting by introducing colour. Of course it was to serve his own purpose that he brought colour back into painting, and he stamped it with his personal feeling, but even allowing for that, he made it seem an objective quality because he used it to interpret something far nobler, because the great brilliant thread of his achievement is the thread of life itself.

Today we are more attracted by Goya, without perhaps realizing that his influence is restrictive. His strikingly personal forms stick in our memory and we wish only to repeat them. Was it not a far higher achievement to stimulate painting through its very essence? Cézanne and Van Gogh were not mistaken when they took Delacroix for their only master.

JEAN PELLOTIER

31

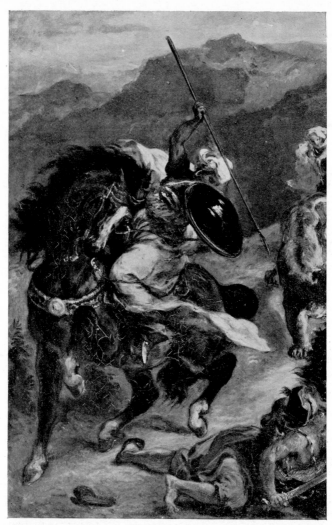

The Lion Hunt / detail / Boston, Museum of Fine Arts

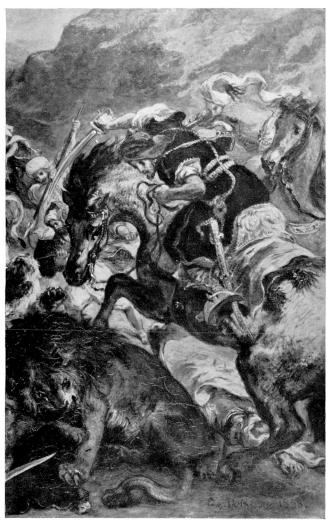

The Lion Hunt / detail / Boston, Museum of Fine Arts

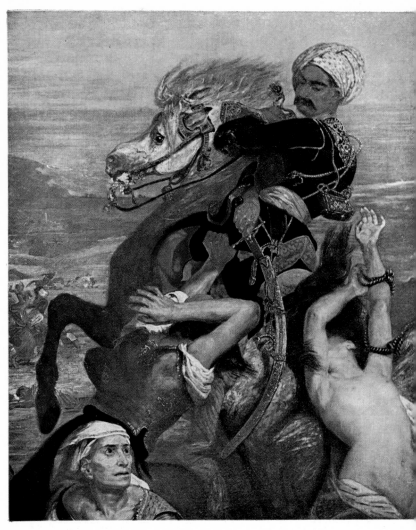

Scenes of the Massacres of Scio / detail / Paris, Louvre

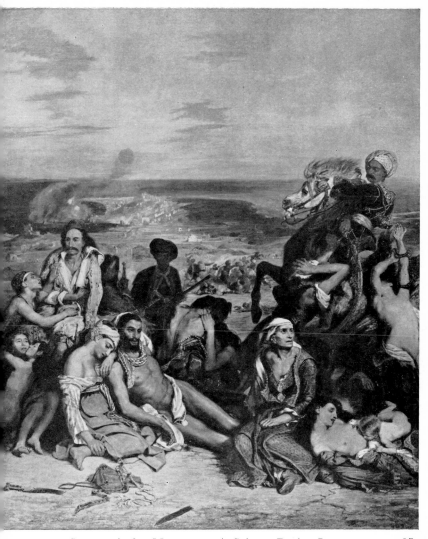

Scenes of the Massacres of Scio / Paris, Louvre 35

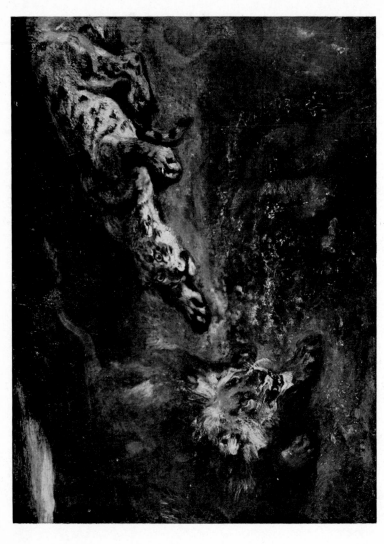

Tiger attacking a Lion / Paris, Bernheim Jeune Collection

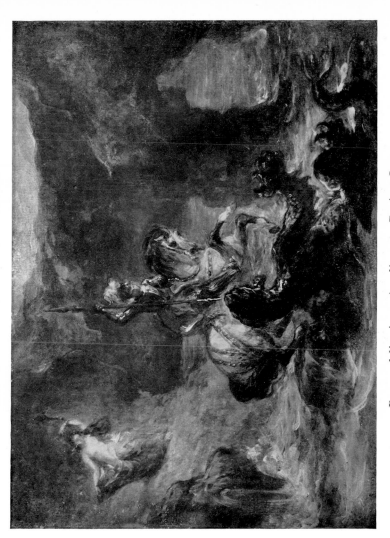

Roger delivering Angelica / Paris, Louvre

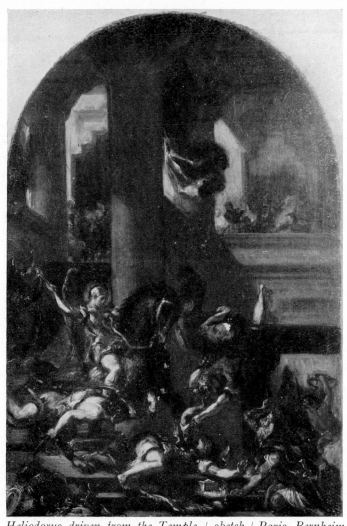

Heliodorus driven from the Temple / sketch / Paris, Bernheim
Jeune Collection

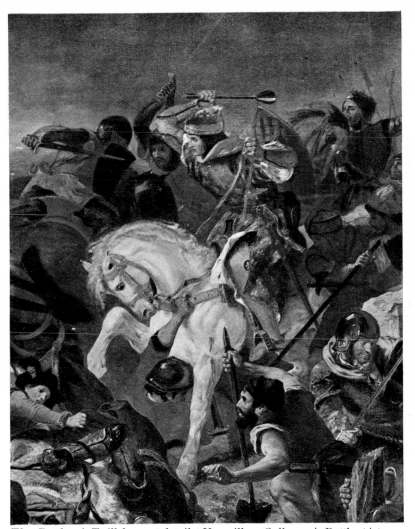

The Battle of Taillebourg / detail / Versailles, Gallery of Battle pictures

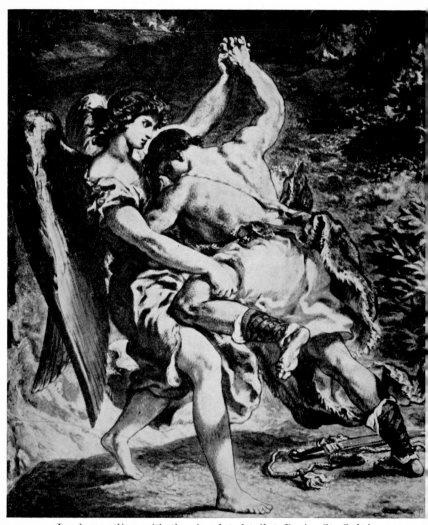

Jacob wrestling with the Angel / detail / Paris, St. Sulpice

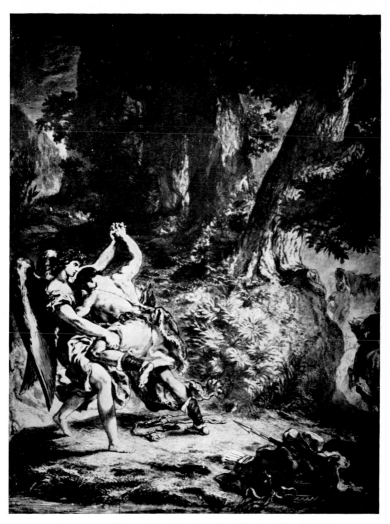

Jacob wrestling with the Angel / Paris, St. Sulpice

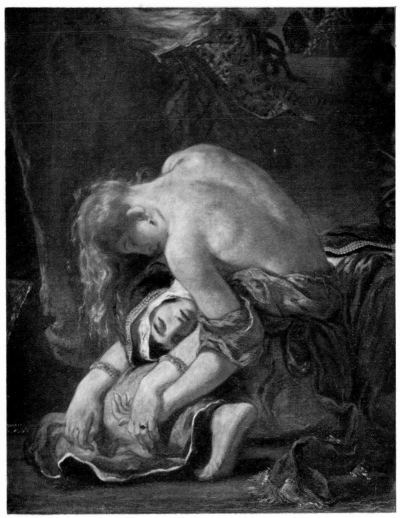

Entry of the Crusaders into Constantinople / detail / Paris, Louvre

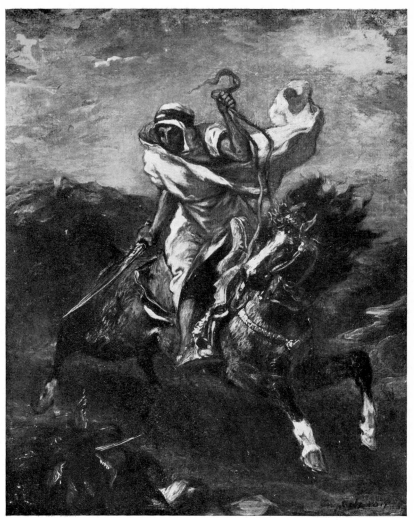

Arab Horseman / Private Collection

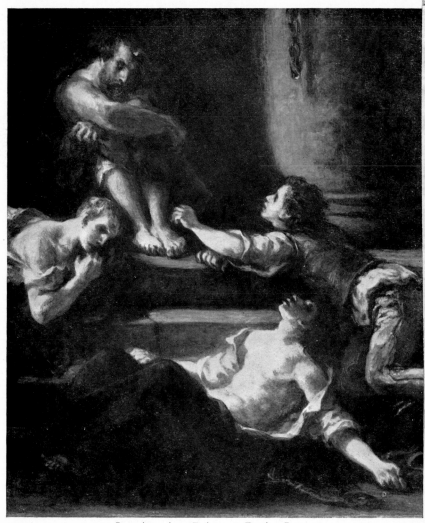

Interior of a Prison / Paris, Louvre

The Sea from the Heights above Dieppe / Paris, formerly Beurdeley Collection

BIOGRAPHY

Delacroix was born at Charenton St. Meurice, near Paris, on August 26th, 1798. His father, Charles Delacroix, was a member of the National Convention and of the Council of Elders. He became Minister for Foreign Affairs in 1797, in which office he was succeeded by Talleyrand.

The family went to live in Marseilles in 1800, approximately. In 1807 Delacroix entered the Lycée Imperial (Louis-le-Grand). In 1813 they made a long visit to Valmont, a beautiful country estate near Fécamp. A year later, on September 3rd, 1814, Delacroix lost his mother. He was then sixteen years old. In 1818 he became a pupil of the painter Guérin. He spent the holidays of 1819 and 1820 in the Forest of Boixe (the ranger's house); became friendly with Géricault, who was seven years older. In 1821 he wrote: "Three or four times a month I have a longing to emigrate to Italy." But he remained in France and painted *Dante and Virgil* in two months and a half. Received great praise from Thiers and Gros: "It is a chastened Rubens."

In 1824, *The Massacre at Scio*. He saw paintings by Constable, and repainted the sky of his Salon picture on the spot. About 1825 he made a journey to London. Made friends with Bonington. The Shakespearian Theatre. At the same period, he was inspired with sympathy for the sufferings of Greece by the poems of Byron. He painted *Liberty on the Barricades* in 1829. Led an active social life.

In January, 1832 he went to Morocco and Spain. On his return he settled down to prepare his mural decorations for the Palais Bourbon. 1834, *The Women of Algiers*. 1837–1841, finished his work in the Salon des Rois. In 1838 he made an excursion to Belgium with Eliza Boulanger, who left him during the expedition. 1842–1847, the two libraries of the Luxembourg and of the Palais Bourbon. The Salon of 1846; Charles Baudelaire.

The revolution of 1848: "I have resigned myself to the inevitable, I have buried the man of yesterday with his hopes and his dreams of the future. We shall all be crowding like beggars round the altar of patriotism."

The magnificent Salon of 1848, *Arab Clowns and Comedians* and *The Entombment*. Sentimental friendship with Elisa Boulanger, now Mme Cavé. Death of his friend Chopin in 1849. Article on Poussin, 1853. Stayed at Champrosay, October 1853. Life with Jenny. Paintings in St. Sulpice 1855. Courbet exhibition. Stayed at Dieppe and Augerville. Illness of 1857. When he was confined to bed he wrote notes for a Dictionary of the Fine Arts and the Definitions of the Beautiful. Plombière. 1861, Paintings in St. Sulpice. Died, August 13th 1863.

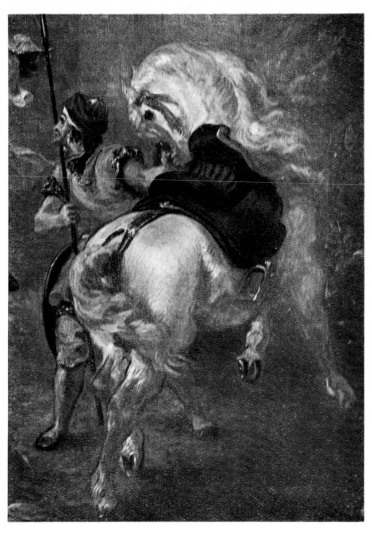

The Abduction of Rebecca by the Templar de Bois Guilbert | detail |
Paris, Louvre

BIBLIOGRAPHY

E. DELACROIX, – Journal
C. BAUDELAIRE – Curiosités Esthétiques.
VAN GOGH – Lettres de Van Gogh à son Frère Théo.
CHARLES BLANC – Grammaire des Arts et du Dessin.
LUCIEN RUDRAUF – Delacroix et le problème du Romantisme Artistique
R. ESCHOLIER – Delacroix (1885).
A. ROBAUT – L'Oeuvre Complet d'Eugène Delacroix (1885).
MOREAU- NELATON – Delacroix raconté par lui-même.
G. JAUNEAU – Le Dessin de Delacroix (1921).
A. BRUYAS – Explication des Ouvrages de Peinture du Cabinet de M
 Albert Bruyas (1854).
J. BERNHEIM – Delacroix, Peintre de Paysage — Bulletin des Musée
 de France (1931).
Numéro Spécial "L'Art et Le Beau", No 4, Eugène Delacroix (1928).